THIS NOTEBOOK BELONGS TO

CONTACT

See our range of fine, illustrated books, ebooks, notebooks and art calendars:
www.flametreepublishing.com

This is a **FLAME TREE NOTEBOOK**
Published and © copyright 2018 Flame Tree Publishing Ltd

FTPB67 • 978-1-78755-053-7

Cover image based on a detail from
Colomba by Octavio Ocampo
© Octavio Ocampo. Octavio Ocampo is represented in Europe
by Emmanuel D. Fouquet, Rangewood Ltd, rangewood@gmail.com

Octavio Ocampo was born in Mexico and grew up in a family of artists.
He was therefore encouraged to be artistic from a very young age and
went on to study painting and sculpture, as well as acting and dancing,
at the Art Institute of San Francisco and La Esmeralda Fine Art Institute
in Mexico City. The metamorphic and surreal painting technique that
Ocampo uses is something to which he has always been attracted.

FLAME TREE PUBLISHING | The Art of Fine Gifts
6 Melbray Mews, London SW6 3NS, United Kingdom